to Elena

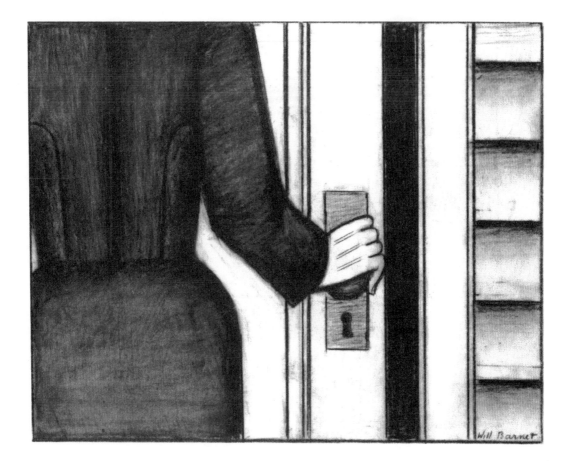

THE WORLD IN A FRAME

Drawings by WILL BARNET

Poems by EMILY DICKINSON

Introduction by CHRISTOPHER BENFEY

Pomegranate

SAN FRANCISCO

Acknowledgments

I wish to thank the following people for their support and help during the various stages of development of this book: George Braziller, for the initial impetus he gave to the idea of my doing this book and for first publishing it in 1989; Katie Burke, whose spirited interest and commitment have led to this new 2006 edition; Beatrice Rehl, for her enthusiasm and support, which were inspirational; Elena, my wife, whose insight into my work has been a great comfort for fifty-three years; my daughter, Ona, who lent her hands and profile to some of the images; Christopher Benfey, for his fine, astute introduction; Joy Sikorski and Dick Barnet, for the many hours they devoted to organizing and coordinating production; and my good friend and colleague Henry Pearson, whose commentaries about poetry and art were invaluable to the evolution of *The World in a Frame*.　　　　　　　　—Will Barnet

Published by Pomegranate Communications, Inc.
Box 808022, Petaluma CA 94975
800 227 1428; www.pomegranate.com

Pomegranate Europe Ltd.
Unit 1, Heathcote Business Centre, Hurlbutt Road
Warwick, Warwickshire CV34 6TD, UK
[+44] 0 1926 430111; sales@pomeurope.co.uk

Introduction © Christopher Benfey, 1989, 2006
Illustrations © Will Barnet, 1989, 2006/Licensed by VAGA, New York, NY
Will Barnet is represented by Babcock Galleries, New York.
First published in the United States of America by George Braziller, Inc. in 1989.

Dickinson poems are reprinted by permission of the publishers and the Trustees of Amherst College from the following volumes: *The Poems of Emily Dickinson,* Thomas H. Johnson, ed., Cambridge, Mass.: The Belknap Press of Harvard University Press, Copyright © 1951, 1955, 1979, 1983 by the President and Fellows of Harvard College; *The Poems of Emily Dickinson: Variorum Edition,* Ralph W. Franklin, ed., Cambridge, Mass.: The Belknap Press of Harvard University Press, Copyright © 1998 by the President and Fellows of Harvard College; *The Poems of Emily Dickinson: Reading Edition,* Ralph W. Franklin, ed., Cambridge, Mass.: The Belknap Press of Harvard University Press, Copyright 1998, 1999 by the President and Fellows of Harvard College.

Library of Congress Cataloging-in-Publication Data

Barnet, Will, 1911–
 The world in a frame / drawings by Will Barnet; poems by Emily Dickinson;
 introduction by Christopher Benfey.
 p. cm.
 ISBN-13: 978-0-7649-3719-4
 ISBN-10: 0-7649-3719-7
 1. Barnet, Will, 1911–. 2. Dickinson, Emily, 1830–1886—Illustrations. I. Dickinson, Emily, 1830–1886.
 Poems. Selections. II. Title.

NC139.B338A4 2006
811'.4—dc22

2006041630

Pomegranate Catalog No. A129
Designed by Lisa Reid
Printed in China
15 14 13 12 11 10 09 08 07 06 10 9 8 7 6 5 4 3 2 1

CONTENTS

THE WORLD IN A FRAME / *Christopher Benfey*

"We do not think enough of the Dead as exhilirants — ," Emily Dickinson once wrote, "they are not dissuaders but Lures — Keepers of that great Romance still to us foreclosed." Revelation was her favorite book of the Bible, with its angelic trumpet blasts and glittering gems, the rococo of the Last Judgment. In one of the handful of poems published during her lifetime, she pictured herself reeling toward heaven in Dionysian celebration, an "Inebriate of Air," while the curious saints

> to windows run —
> To see the little Tippler
> Leaning against the — Sun — (214)

Will Barnet has chosen this ecstatic image as his opening for a series of drawings that respond to the lure and allure of Dickinson's poetry.

Death as exhilaration instead of exile: it's a notion we would expect to find in New Orleans rather than in New England. There were raised eyebrows at Dickinson's funeral in 1886, for which, deliberate to the end, she'd left careful instructions. She refused the hearse, the church, the black crepe of nineteenth-century, upper-class obsequies. She asked to leave by the back door of the large brick house in Amherst, Massachusetts, in which she was born in 1830 and where she died. Then she wanted her coffin carried through the garden and the opened barn, and across the fields of mown grass to the family plot where her parents were buried. During the whole procession her coffin was always in view of her house. Instead of the town worthies who had served as pallbearers for her father, a distinguished lawyer and former US congressman, she elected the six Irish workmen her father had employed to care for his land and animals.

One shocked Amherst gossip noted in her diary: "Emily Dickinson's funeral observed, private, no flowers, taken to the Cemetery — by Irishmen, out of the back door, across the fields!! her request." The steady crescendo of amazement needs some deciphering. Within the strict Trinitarian Protestantism of Amherst in the 1880s, the Roman Catholic Irishmen struck a note of discord, as did the

rear exit, which, as the cultural historian Barton St. Armand notes, was "traditionally reserved only for murderers, reprobates, and outcasts."

Dickinson was a nonconformist in her poetry and in her conduct, but I think she chose the Irish workmen and the back door less to shock than to declare her allegiance to this particular expanse of land. These men had worked it, this door opened onto it. And across these fields she wanted to be carried, more in celebration than in lamentation. I can't help but feel that she would have approved of Will Barnet's childhood pastime of playing ball in the old Puritan cemetery in Beverly, Massachusetts, where he grew up. The arrival of somber mourners was an unwelcome intrusion, as conveyed in her poem and in his drawing (pages 80–81).

Dickinson was a New England poet first by birth and then by choice. She is frank about her prejudices: "The Robin's my Criterion for Tune — ," she writes, "Because I grow — where Robins do — ":

> Without the Snow's Tableau
> Winter, were lie — to me —
> Because I see — New Englandly —
> The Queen, discerns like me —
> Provincially — (285)

There's a fine boast in those last two lines: she's provincial, yes, but she takes as her province all of creation. She seems to anticipate those anxious ethnographers of our own century who take as the first step to lucidity acknowledgment of the effects of our own presence and point of view on the people and places we experience.

Dickinson's funeral — more pageant than somber procession — may seem especially bizarre when we consider what we all know about her life: how she was born in Amherst and died there; never married; almost never published, or traveled; and how late in life she refused to see, or be seen by, anyone but her family and closest friends. But scholars and cultural historians have made us revise our image of a life lived in isolation and renunciation — that "piercing virtue," as Dickinson called it. Her family was quite prominent and relatively

wealthy, the leading family in the college town of Amherst. Both her father and her brother Austin attended Yale, and Austin went on to the Harvard Law School. Austin's wife, Susan Gilbert, well educated and a close friend of Emily Dickinson, hosted an impressive group of literary visitors to Amherst, including Emerson, while Austin was a connoisseur and collector of art, and numbered among his close friends the great city planner and designer of Central Park, Frederick Law Olmsted. (Olmsted, in fact, laid out the grounds of the Italianate mansion where Susan and Austin lived, next door to the Dickinson house on Main Street.) Dickinson herself carried on long correspondences with some of the leading literary figures of New England, including Helen Hunt Jackson, the novelist and agitator for the rights of American Indians, who encouraged her, in vain, to allow her poems to be published; and Thomas Wentworth Higginson — minister, abolitionist, Civil War commander of a regiment of black troops — whom she asked for advice about her poetry. From her stronghold in the family house in Amherst, she had, as we would say today, very good connections.

It has long been known that Emily Dickinson experienced some extreme affliction in the early 1860s, as though in sympathy with the national rending of the Civil War. To Higginson she wrote in April 1862:

> I had a terror — since September —
> I could tell to none — and so I sing,
> as the Boy does by the Burying Ground —
> because I am afraid —

Scholars have been eager to believe that the shock was a romantic one, and several suitors have been nominated — including a minister or two. (This despite the fact that she said of her family: "They are religious — except me — and address an Eclipse, every morning — whom they call their 'Father.'") In a 1988 biography, however, Cynthia Griffin Wolff has made a forceful case that the crisis was physical, an affliction of the eyes that threatened blindness. Dickinson did visit an eye doctor in Cambridge in 1862 and, after what must have been excruciating treatment, turned with delight to the books that had been closed to her. As Higginson commented, "After long disuse of her eyes she read Shakespeare & thought why is

any other book needed." It is such a moment that Will Barnet has caught in his drawing for her poem "Unto my Books — so good to turn" (pages 50–51).

Whatever the cause, or combination of causes, the result of Dickinson's crisis in the 1860s was a new and commanding sense of herself as a poet — her vision threatened and reaffirmed:

> Must be a Woe —
> A loss or so —
> To bend the eye
> Best Beauty's way —
>
> But — once aslant
> It notes Delight
> As difficult
> As Stalactite (571)

Here the key word is "aslant": it is only by indirection, Dickinson suggests, that we can perceive and express the blinding splendor of the world. This is her version of the sublime, the peculiar mix of pleasure and pain that is at the heart of eighteenth- and much nineteenth-century aesthetics:

> Tell all the Truth but tell it slant —
> Success in Circuit lies
> Too bright for our infirm Delight
> The Truth's superb surprise
>
> As Lightning to the Children eased
> With explanation kind
> The Truth must dazzle gradually
> Or every man be blind — (1129)

Of Dickinson's taste in paintings we don't know much. She drew her ideas on art from Ruskin — one of her favorite writers — from magazine articles and illustrations, and probably from Robert Browning's dramatic monologues spoken by Italian painters. She never visited museums, hardly ever left Amherst, and

probably saw few paintings other than her brother's, which included fine ones by Kensett and other painters of the Hudson River School. But she shares with those American painters, especially with those who participated in the "Luminism" movement, a taste for outsized subjects — mountains, electrical storms, sunsets — and natural sublimity.

She likes to point out how inadequate a painting is in comparison with the scene it depicts. "How mean — to those that see — / Vandyke's Delineation / of Nature's — Summer Day." For those who can't see (she calls them the "Races — nurtured in the Dark") she offers little hope for conveying the sublimity of the sun:

> Can Blaze be shown in Cochineal —
> Or Noon — in Mazarin? (581)

But in her evident pleasure in the plush names of those pigments, she suggests that her words might do better than paint. Among the "Visions [that] flitted Guido — / Titian — never told — ," she mentions the sublimity of the sunset: "How the old Mountains drip with Sunset." But "drip" suggests that the mountains are themselves covered with paint, as though the setting sun were as prodigal as Albert Pinkham Ryder with his thickly applied impasto. In her wordplay she competes with painters, dares them to outdo her.

For centuries artists of the Western tradition have painted the world as though seen through a frame, especially a window frame. Windows and doors mark a passage from the interior to the world outside; "The Inner — paints the Outer — / The Brush without the Hand — ," Dickinson wrote. In several of the drawings Will Barnet has been particularly responsive to Emily Dickinson's habitual practice of beholding the world through a frame. She seems to have taken to heart Edgar Allan Poe's contention that "a close circumscription of space is absolutely necessary to the effect of insulated incident: — it has the force of a frame to a picture."

The incidents that interest her most are seasonal. In one of her most beautiful poems, published for the first time in 1945, she notes how "The Seasons — shift — my Picture — " as she sits by her window:

The Angle of a Landscape —
That every time I wake —
Between my Curtain and the Wall
Upon an ample Crack —

Like a Venetian — waiting —
Accosts my open eye —
Is just a Bough of Apples —
Held slanting, in the Sky — (375)

The momentary confusion of branch and horizon, foreground and background, resembles Cézanne's meditations on branch and mountain in his Mont Sainte-Victoire paintings, while the mysterious slanting angle of the bough echoes Dickinson's continuing preoccupation with indirection.

She returns to the theme in one of her greatest poems, another seasonal, at-the-window poem — "There's a certain Slant of light, / Winter Afternoons — ," where the window opens something inside her:

Heavenly Hurt, it gives us —
We can find no scar,
But internal difference,
Where the Meanings, are — (258)

Will Barnet's closing image for the poem that begins "The earth has many keys" may also have a seasonal focus; the late Dickinson scholar Jay Leyda once told me that he was convinced that these stanzas are in fact an alternative ending for Dickinson's beautiful poem "Further in Summer than the Birds" (page 29). All of these poems of seasonal change as viewed from a window bear an uncanny resemblance to the series of four paintings by Will Barnet, now in the Whitney Museum of American Art, New York, called "The Silent Seasons," which depict a girl in profile hunched over a table by a window. The colors and lighting change, but the abstract pattern of forms — girl, table, window frame, tree — does not.

Optical illusions are among her favorite topics:

By my Window have I for Scenery
Just a Sea — with a Stem —
If the Bird and the Farmer — deem it a "Pine" —
The Opinion will serve — for them — (797)

Here the visual pun of the trickster landscape is reinforced by a verbal one, on "a Pine" and "Opinion." In another, more serious poem she notes that "Delight — becomes pictorial — / When viewed through Pain — "

The Mountain — at a given distance —
In Amber — lies —
Approached — the Amber flits — a little —
And That's — the Skies — (572)

In such poems Dickinson attends to illusory effects less for their trickery than for the promise of mystery lurking in the physiognomy of the landscape:

The eager look — on Landscapes —
As if they just repressed
Some Secret — that was pushing
Like Chariots — in the Vest — (627)

Dickinson's pleasure in the small, rectangular stanzas (the Italian word means "rooms") of ballads and hymns is related to her use of frames. She often describes herself as dwelling "in corners." This wallflower modesty has often been interpreted as her exile in the male-dominated society of nineteenth-century Amherst, but I think she also means that the vitality of a frame — of window, or painting, or stanza — occurs in the corners. Her off-rhymes and slant-rhymes italicize the corners of her stanzas. Similarly, Will Barnet "works from corner to corner," as he has remarked. His cat lurks in one corner while a bird escapes to another (page 59). In another drawing (page 51), the woman in the library looks from her chair in the lower left corner toward the tree in the upper right window.

In one of the strange tales of E. T. A. Hoffmann, a man orders a huge

house built for himself. He has the four massive walls raised first, then with a hammer he knocks out holes for windows and doors. If he had, like Emily Dickinson, a mania for definition, he might say that a house is a prison with an escape route. The corollary would be Dickinson's assertion that "Doom is the House without the Door." Every reader of Dickinson is familiar with the profusion of doors and windows in her poems: how the soul selects her own society, then shuts the door; how she chooses to dwell in possibility, a fairer house than prose, because "More numerous of Windows — / Superior — for Doors." In poem after poem Dickinson tries to imagine a house that is a refuge without being a prison, a place of companionship without being a hotel. The image that satisfies her most is the door ajar. "Ajar — secure — inviting": this sequence of adjectives, loosely aligned by connective dashes, defines Dickinson's favorite relation to the world. She demands the safety of a door she can shut, but also the open invitation of a world she can see in the frame of the window, and paint in the frame of a poem.

Two New England artists are represented in this book, in dialogue. Will Barnet's drawings are in response to Emily Dickinson's poems, just as many of her poems were created in response to paintings and the look of landscapes. The poet is particularly insightful about the visual world around her. The painter is particularly responsive to the wit and allure of language. Both of these artists are working to achieve a satisfying relation in their work between the abstract forms of frame and stanza, and the actual furniture of their lives. The book, in effect, elicits the poet in the painter, the painter in the poet.

A Note on Sources

During the composition of this essay I have found several books particularly useful. For details of Dickinson's visual culture and her funeral, I relied on Barton St. Armand's *Emily Dickinson and Her Culture* (Cambridge University Press, 1984). For a fresh reading of Dickinson's work I'm grateful to have encountered Susan Howe's *My Emily Dickinson* (North Atlantic Books, 1985). And for the shape of Dickinson's life, Richard Sewall's biography (Farrar, Straus & Giroux, 1974) remains essential.

The World in a Frame

I dwell in Possibility —
A fairer House than Prose —
More numerous of Windows —
Superior — for Doors —

Of Chambers as the Cedars —
Impregnable of Eye —
And for an Everlasting Roof
The Gambrels of the Sky —

Of Visitors — the fairest —
For Occupation — This —
The spreading wide my narrow Hands
To gather Paradise —

I taste a liquor never brewed —
From Tankards scooped in Pearl —
Not all the Vats upon the Rhine
Yield such an Alcohol!

Inebriate of Air — am I —
And Debauchee of Dew —
Reeling — thro endless summer days —
From inns of Molten Blue —

When "Landlords" turn the drunken Bee
Out of the Foxglove's door —
When Butterflies — renounce their "drams"
I shall but drink the more!

Till Seraphs swing their snowy Hats —
And Saints — to windows run —
To see the little Tippler
Leaning against the — Sun —

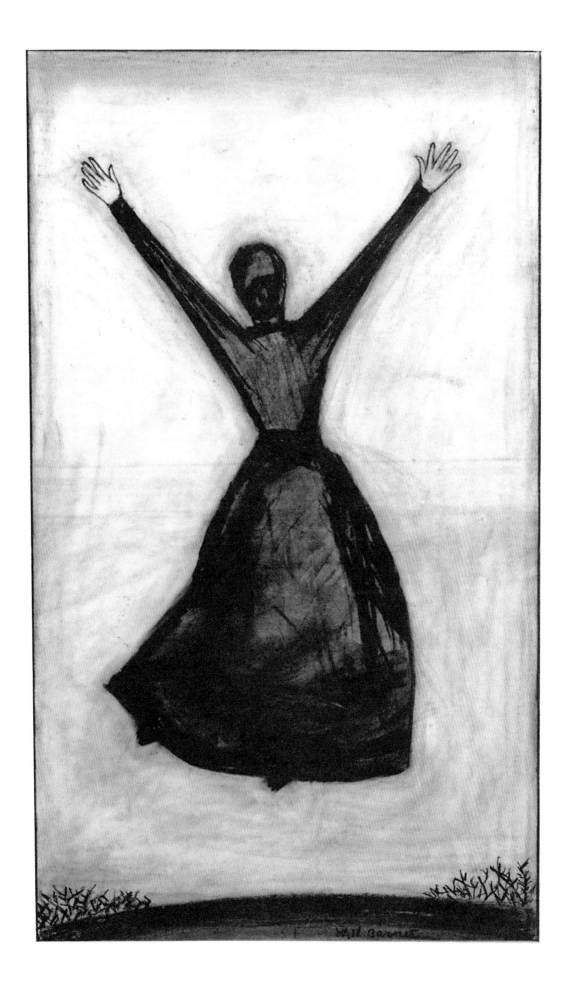

I would not paint — a picture —
I'd rather be the One
Its bright impossibility
To dwell — delicious — on —
And wonder how the fingers feel
Whose rare — celestial — stir —
Evokes so sweet a Torment —
Such sumptuous — Despair —

I would not talk, like Cornets —
I'd rather be the One
Raised softly to the Ceilings —
And out, and easy on —
Through Villages of Ether —
Myself endued Balloon
By but a lip of Metal —
The pier to my Pontoon —

Nor would I be a Poet —
It's finer — own the Ear —
Enamored — impotent — content —
The License to revere,
A privilege so awful
What would the Dower be,
Had I the Art to stun myself
With Bolts of Melody!

783

The Birds begun at Four o'clock —
Their period for Dawn —
A Music numerous as space —
But neighboring as Noon —

I could not count their Force —
Their Voices did expend
As Brook by Brook bestows itself
To multiply the Pond.

Their Witnesses were not —
Except occasional man —
In homely industry arrayed —
To overtake the Morn —

Nor was it applause —
That I could ascertain —
But independent Ecstasy
Of Deity and Men —

By Six, the flood had done —
No Tumult there had been
Of Dressing, or Departure —
And yet the Band was gone —

The Sun engrossed the East —
The Day controlled the World —
The Miracle that introduced
Forgotten, as fulfilled.

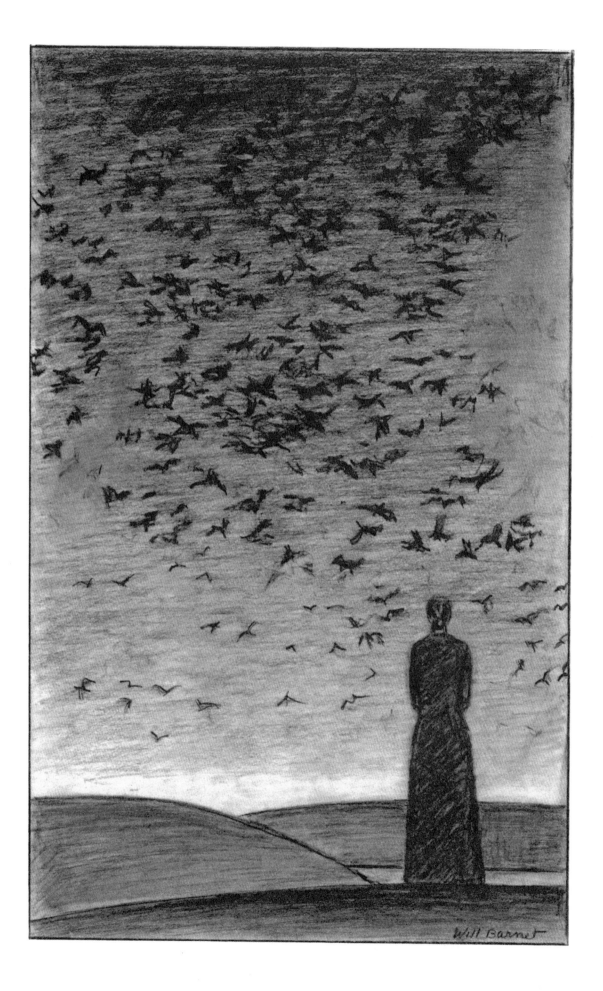

1472

To see the Summer Sky
Is Poetry, though never in a Book it lie —
True Poems flee —

Two Butterflies went out at Noon —
And waltzed upon a Farm —
Then stepped straight through the Firmament
And rested, on a Beam —

And then — together bore away
Upon a shining Sea —
Though never yet, in any Port —
Their coming, mentioned — be —

If spoken by the distant Bird —
If met in Ether Sea
By Frigate, or by Merchantman —
No notice — was — to me —

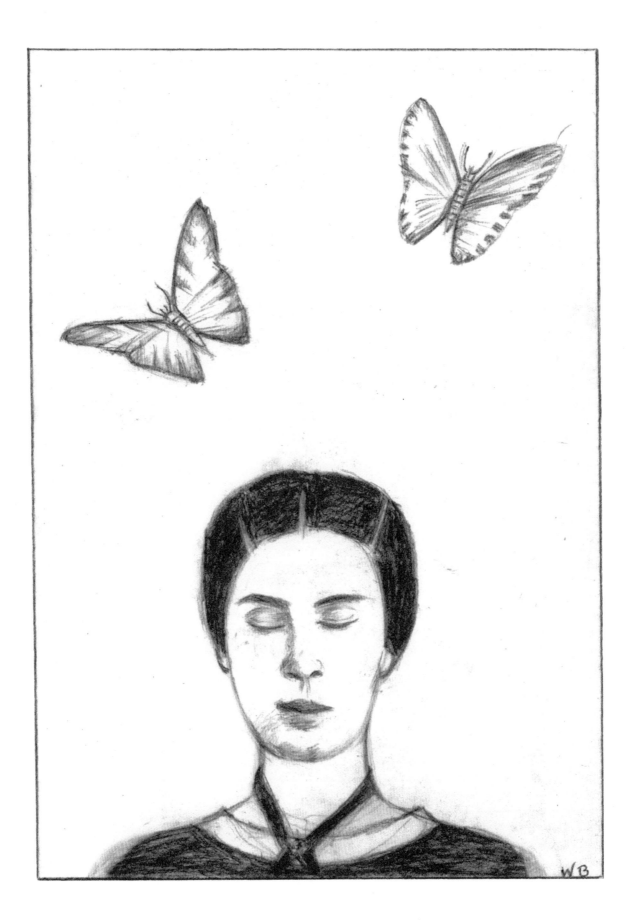

1068

Further in Summer than the Birds
Pathetic from the Grass
A minor Nation celebrates
Its unobtrusive Mass.

No Ordinance be seen
So gradual the Grace
A pensive Custom it becomes
Enlarging Loneliness.

Antiquest felt at Noon
When August burning low
Arise this spectral Canticle
Repose to typify

Remit as yet no Grace
No Furrow on the Glow
Yet a Druidic Difference
Enhances Nature now

The Spider as an Artist
Has never been employed —
Though his surpassing Merit
Is freely certified

By every Broom and Bridget
Throughout a Christian Land —
Neglected Son of Genius
I take thee by the Hand —

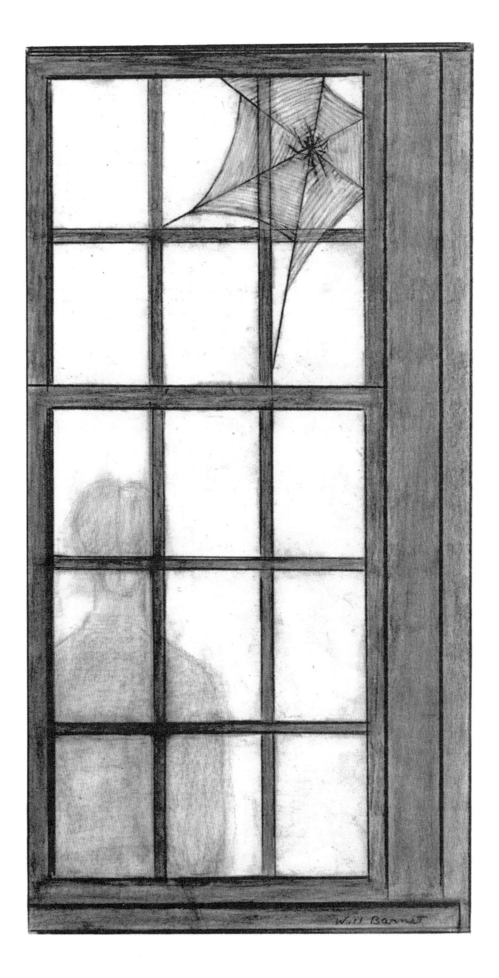

606

The Trees like Tassels — hit — and swung —
There seemed to rise a Tune
From Miniature Creatures
Accompanying the Sun —

Far Psalteries of Summer —
Enamoring the Ear
They never yet did satisfy —
Remotest — when most fair

The Sun shone whole at intervals —
Then Half — then utter hid —
As if Himself were optional
And had Estates of Cloud

Sufficient to enfold Him
Eternally from view —
Except it were a whim of His
To let the Orchards grow —

A Bird sat careless on the fence —
One gossiped in the Lane
On silver matters charmed a Snake
Just winding round a Stone —

Bright Flowers slit a Calyx
And soared upon a Stem
Like Hindered Flags — Sweet hoisted —
With Spices — in the Hem —

'Twas more — I cannot mention —
How mean — to those that see —
Vandyke's Delineation
Of Nature's — Summer Day!

There's a certain Slant of light,
Winter Afternoons —
That oppresses, like the Heft
Of Cathedral Tunes —

Heavenly Hurt, it gives us —
We can find no scar,
But internal difference,
Where the Meanings, are —

None may teach it — Any —
'Tis the Seal Despair —
An imperial affliction
Sent us of the Air —

When it comes, the Landscape listens —
Shadows — hold their breath —
When it goes, 'tis like the Distance
On the look of Death

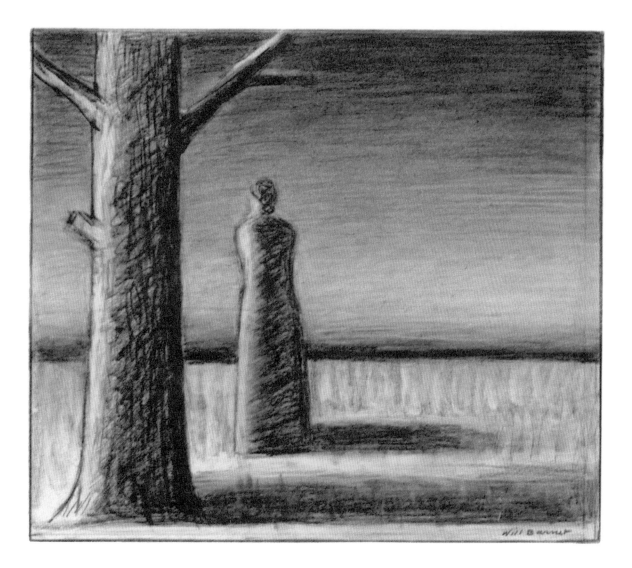

The Tint I cannot take — is best —
The Color too remote
That I could show it in Bazaar —
A Guinea at a sight —

The fine — impalpable Array —
That swaggers on the eye
Like Cleopatra's Company —
Repeated — in the sky —

The Moments of Dominion
That happen on the Soul
And leave it with a Discontent
Too exquisite — to tell —

The eager look — on Landscapes —
As if they just repressed
Some Secret — that was pushing
Like Chariots — in the Vest —

The Pleading of the Summer —
That other Prank — of Snow —
That Cushions Mystery with Tulle,
For fear the Squirrels — know.

Their Graspless manners — mock us —
Until the Cheated Eye
Shuts arrogantly — in the Grave —
Another way — to see —

506

He touched me, so I live to know
That such a day, permitted so,
I groped upon his breast —
It was a boundless place to me
And silenced, as the awful sea
Puts minor streams to rest.

And now, I'm different from before,
As if I breathed superior air —
Or brushed a Royal Gown —
My feet, too, that had wandered so —
My Gypsy face — transfigured now —
To tenderer Renown —

Into this Port, if I might come,
Rebecca, to Jerusalem,
Would not so ravished turn —
Nor Persian, baffled at her shrine
Lift such a Crucifixal sign
To her imperial Sun.

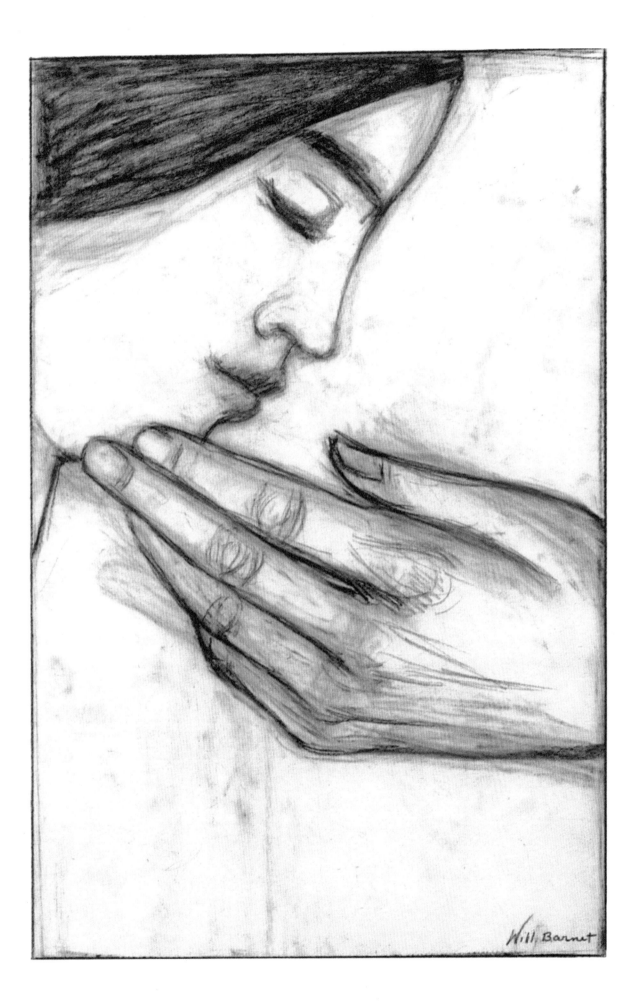

Will Barnet

211

Come slowly — Eden!
Lips unused to Thee —
Bashful — sip thy Jessamines
As the fainting Bee —

Reaching late his flower,
Round her chamber hums —
Counts his nectars —
Enters — and is lost in Balms.

Wild Nights — Wild Nights!
Were I with thee
Wild Nights should be
Our luxury!

Futile — the Winds —
To a Heart in port —
Done with the Compass —
Done with the Chart!

Rowing in Eden —
Ah, the Sea!
Might I but moor — Tonight —
In Thee!

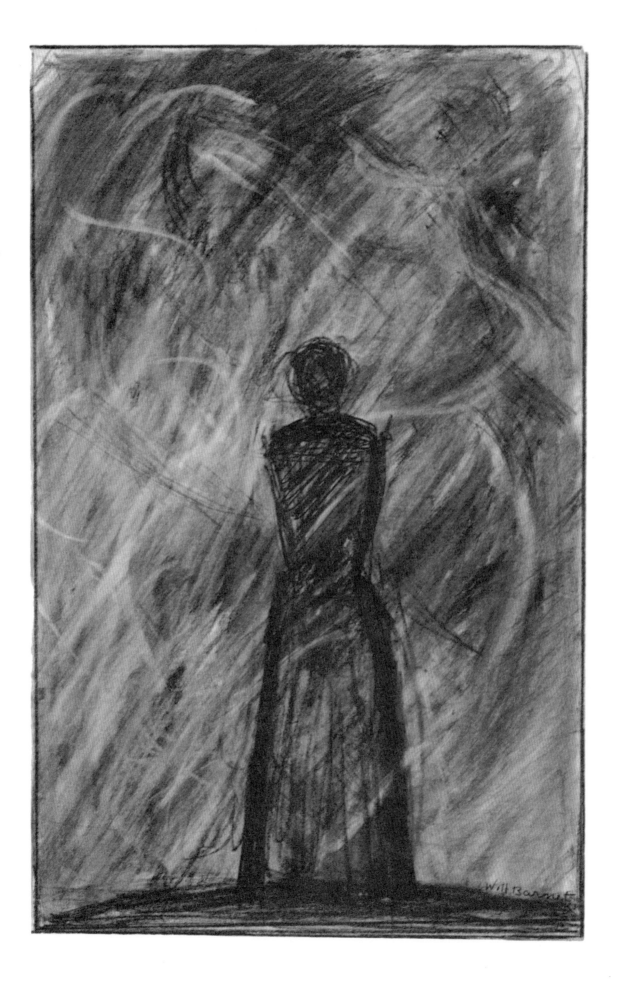

There came a Day at Summer's full,
Entirely for me —
I thought that such were for the Saints,
Where Resurrections — be —

The Sun, as common, went abroad,
The flowers, accustomed, blew,
As if no soul the solstice passed
That maketh all things new —

The time was scarce profaned, by speech —
The symbol of a word
Was needless, as at Sacrament,
The Wardrobe — of our Lord —

Each was to each The Sealed Church,
Permitted to commune this — time —
Lest we too awkward show
At Supper of the Lamb.

The Hours slid fast — as Hours will,
Clutched tight, by greedy hands —
So faces on two Decks, look back,
Bound to opposing lands —

And so when all the time had leaked,
Without external sound
Each bound the Other's Crucifix —
We gave no other Bond —

Sufficient troth, that we shall rise —
Deposed — at length, the Grave —
To that new Marriage,
Justified — through Calvaries of Love —

I am ashamed — I hide —
What right have I — to be a Bride —
So late a Dowerless Girl —
Nowhere to hide my dazzled Face —
No one to teach me that new Grace —
Nor introduce — my Soul —

Me to adorn — How — tell —
Trinket — to make Me beautiful —
Fabrics of Cashmere —
Never a Gown of Dun — more —
Raiment instead — of Pompadour —
For Me — My soul — to wear —

Fingers — to frame my Round Hair
Oval — as Feudal Ladies wore —
Far Fashions — Fair —
Skill — to hold my Brow like an Earl —
Plead — like a Whippoorwill —
Prove — like a Pearl —
Then, for Character —

Fashion My Spirit quaint — white —
Quick — like a Liquor —
Gay — like Light —
Bring Me my best Pride —
No more ashamed —
No more to hide —
Meek — let it be — too proud — for Pride —
Baptized — this Day — A Bride —

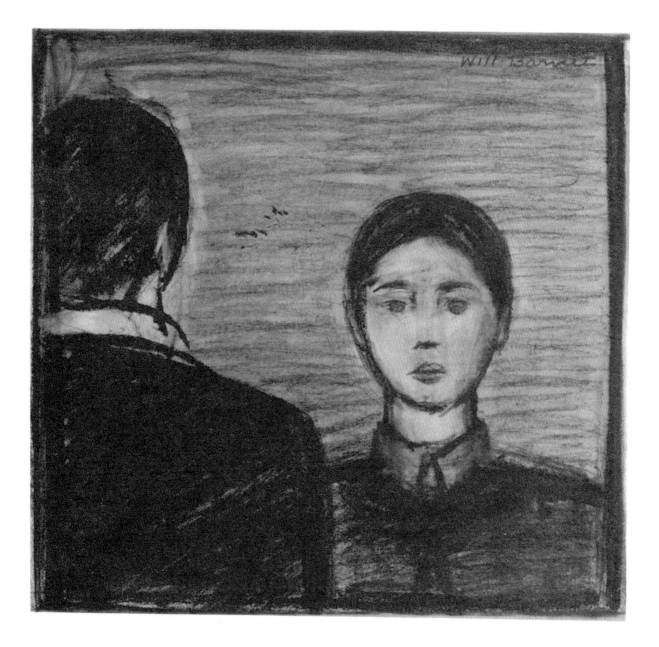

Least Rivers — docile to some sea.
My Caspian — thee.

604

Unto my Books — so good to turn —
Far ends of tired Days —
It half endears the Abstinence —
And Pain — is missed — in Praise —

As Flavors — cheer Retarded Guests
With Banquettings to be —
So Spices — stimulate the time
Till my small Library —

It may be Wilderness — without —
Far feet of failing Men —
But Holiday — excludes the night —
And it is Bells — within —

I thank these Kinsmen of the Shelf —
Their Countenances Kid
Enamor — in Prospective —
And satisfy — obtained —

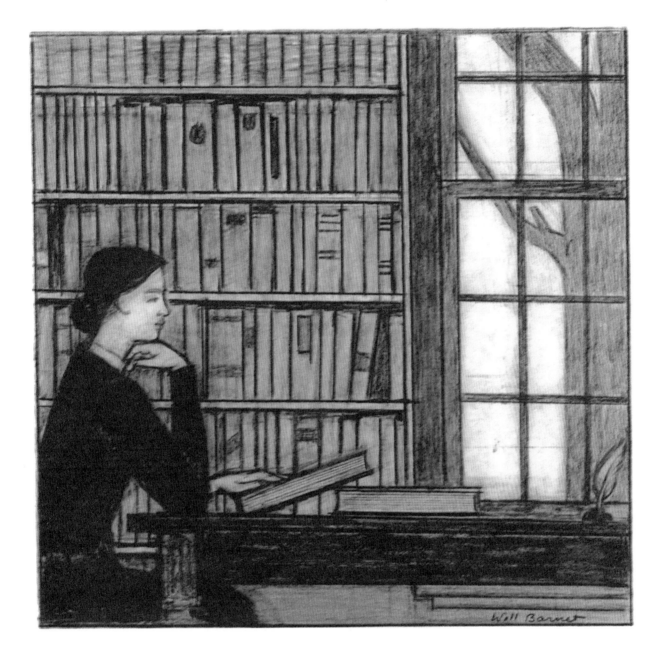

Besides the Autumn poets sing
A few prosaic days
A little this side of the snow
And that side of the Haze —

A few incisive Mornings —
A few Ascetic Eves —
Gone — Mr. Bryant's "Golden Rod" —
And Mr. Thomson's "sheaves."

Still, is the bustle in the Brook —
Sealed are the spicy valves —
Mesmeric fingers softly touch
The Eyes of many Elves —

Perhaps a squirrel may remain —
My sentiments to share —
Grant me, Oh Lord, a sunny mind —
Thy windy will to bear!

636

The Way I read a Letter's — this —
'Tis first — I lock the Door —
And push it with my fingers — next —
For transport it be sure —

And then I go the furthest off
To counteract a knock —
Then draw my little Letter forth
And slowly pick the lock —

Then — glancing narrow, at the Wall —
And narrow at the floor
For firm Conviction of a Mouse
Not exorcised before —

Peruse how infinite I am
To no one that You — know —
And sigh for lack of Heaven — but not
The Heaven God bestow —

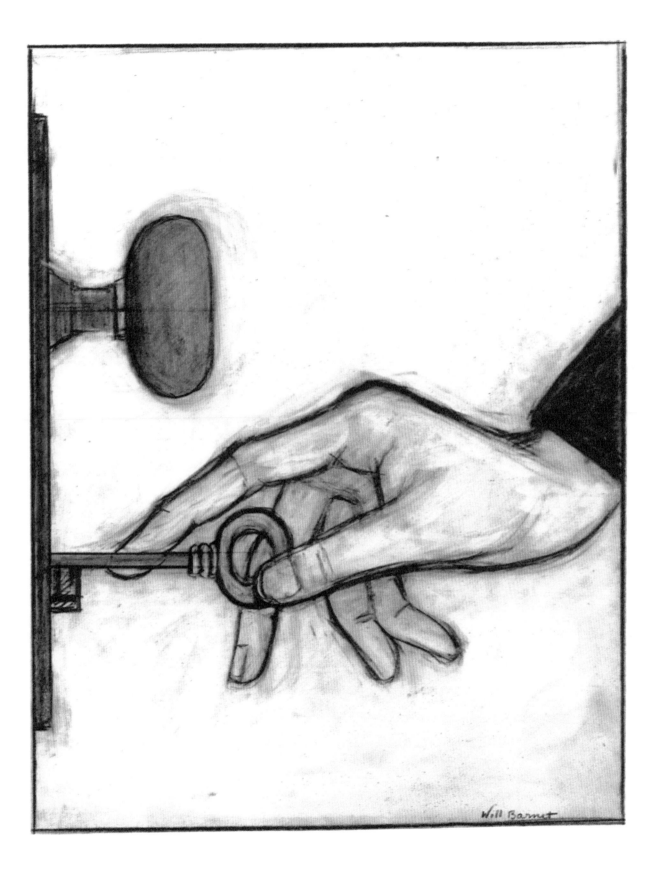

Will Barnet

1127

Soft as the massacre of Suns
By Evening's Sabres slain

507

She sights a Bird — she chuckles —
She flattens — then she crawls —
She runs without the look of feet —
Her eyes increase to Balls —

Her Jaws stir — twitching — hungry —
Her Teeth can hardly stand —
She leaps, but Robin leaped the first —
Ah, Pussy, of the Sand,

The Hopes so juicy ripening —
You almost bathed your Tongue —
When Bliss disclosed a hundred Toes —
And fled with every one —

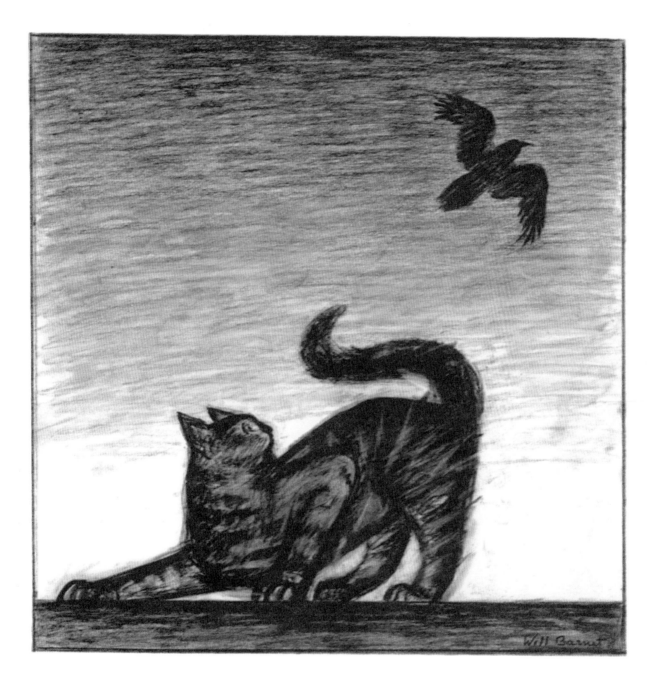

1278

The Mountains stood in Haze —
The Valleys stopped below
And went or waited as they liked
The River and the Sky.

At leisure was the Sun —
His interests of Fire
A little from remark withdrawn —
The Twilight spoke the Spire,

So soft upon the Scene
The Act of evening fell
We felt how neighborly a Thing
Was the Invisible.

441

This is my letter to the World
That never wrote to Me —
The simple News that Nature told —
With tender Majesty

Her Message is committed
To Hands I cannot see —
For love of Her — Sweet — countrymen —
Judge tenderly — of Me

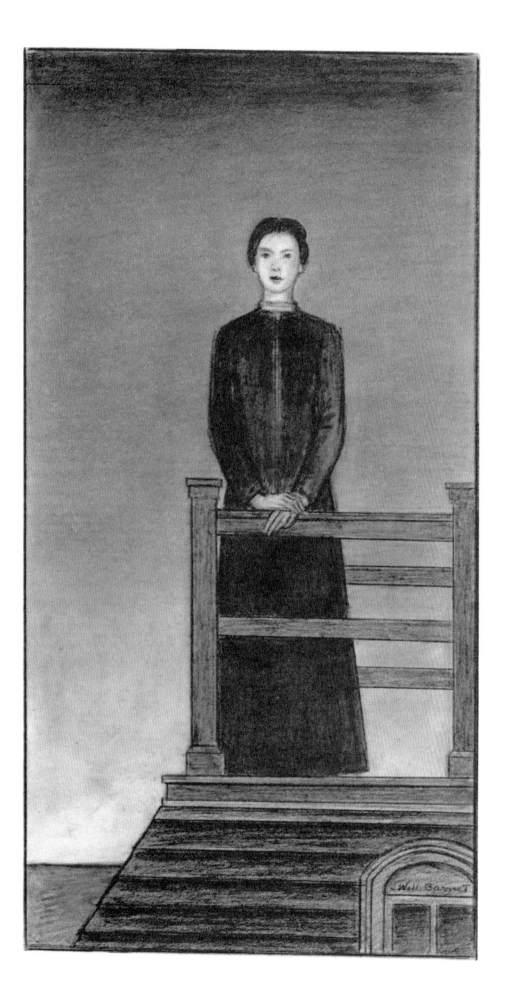

628

They called me to the Window, for
"'Twas Sunset" — Some one said —
I only saw a Sapphire Farm —
And just a Single Herd —

Of Opal Cattle — feeding far
Upon so vain a Hill —
As even while I looked — dissolved —
Nor Cattle were — nor Soil —

But in their stead — a Sea — displayed —
And Ships — of such a size
As Crew of Mountains — could afford —
And Decks — to seat the skies —

This — too — the Showman rubbed away —
And when I looked again —
Nor Farm — nor Opal Herd — was there —
Nor Mediterranean —

The Angle of a Landscape
That every time I wake —
Between my Curtain and the Wall
Upon an ample Crack —

Like a Venetian — waiting —
Accosts my open eye —
Is just a Bough of Apples —
Held slanting, in the Sky —

The Pattern of a Chimney —
The Forehead of a Hill —
Sometimes — a Vane's Forefinger —
But that's — Occasional —

The Seasons — shift — my Picture —
Upon my Emerald Bough,
I wake — to find no — Emeralds —
Then — Diamonds — which the Snow

From Polar Caskets — fetched me —
The Chimney — and the Hill —
And just the Steeple's finger —
These — never stir at all —

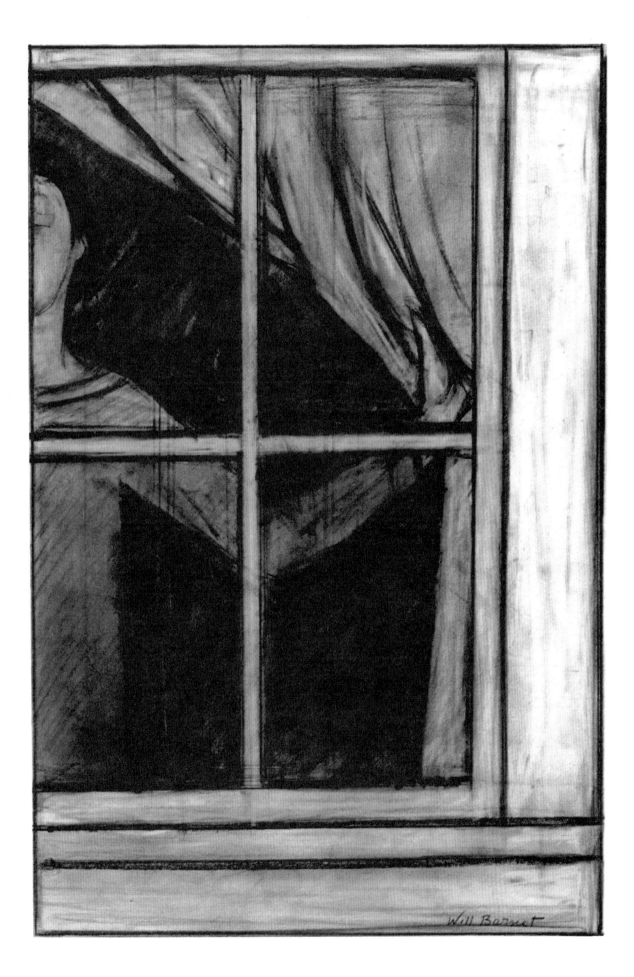

Will Barnet

Four Trees — upon a solitary Acre —
Without Design
Or Order, or Apparent Action —
Mountain —

The Sun — upon a Morning meets them —
The Wind —
No nearer Neighbor — have they —
But God —

The Acre gives them — Place —
They — Him — Attention of Passer by —
Of Shadow, or of Squirrel, haply —
Or Boy —

What Deed is Theirs unto the General Nature —
What Plan
They severally — retard — or further —
Unknown —

Presentiment — is that long Shadow — on the Lawn —
Indicative that Suns go down —

The Notice to the startled Grass
That Darkness — is about to pass —

Will Barnet

291

How the old Mountains drip with Sunset
How the Hemlocks burn —
How the Dun Brake is draped in Cinder
By the Wizard Sun —

How the old Steeples hand the Scarlet
Till the Ball is full —
Have I the lip of the Flamingo
That I dare to tell?

Then, how the Fire ebbs like Billows —
Touching all the Grass
With a departing — Sapphire — feature —
As a Duchess passed —

How a small Dusk crawls on the Village
Till the Houses blot
And the odd Flambeau, no men carry
Glimmer on the Street —

How it is Night — in Nest and Kennel —
And where was the Wood —
Just a Dome of Abyss is Bowing
Into Solitude —

These are the Visions flitted Guido —
Titian — never told —
Domenichino dropped his pencil —
Paralyzed, with Gold —

1764

The saddest noise, the sweetest noise,
 The maddest noise that grows, —
The birds, they make it in the spring,
 At night's delicious close.

Between the March and April line —
 That magical frontier
Beyond which summer hesitates,
 Almost too heavenly near.

It makes us think of all the dead
 That sauntered with us here,
By separation's sorcery
 Made cruelly more dear.

It makes us think of what we had,
 And what we now deplore.
We almost wish those siren throats
 Would go and sing no more.

An ear can break a human heart
 As quickly as a spear,
We wish the ear had not a heart
 So dangerously near.

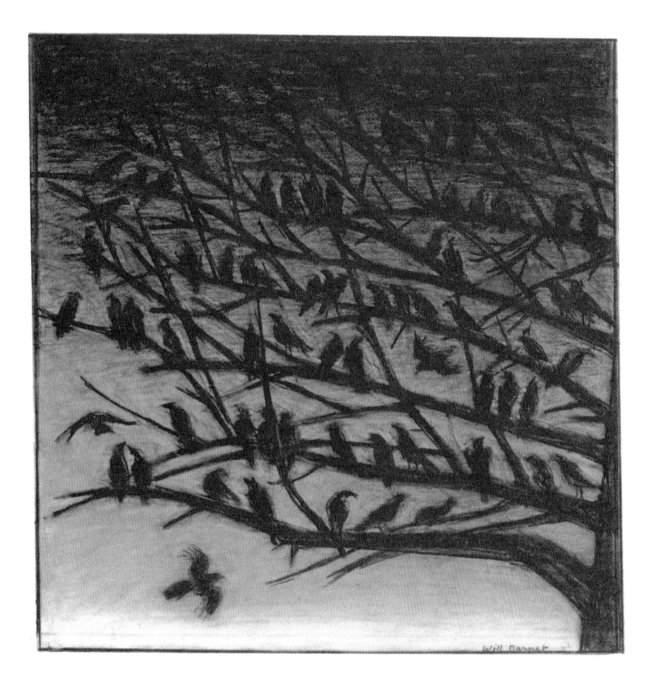

692

The Sun kept setting — setting — still
No Hue of Afternoon —
Upon the Village I perceived —
From House to House 'twas Noon —

The Dusk kept dropping — dropping — still
No Dew upon the Grass —
But only on my Forehead stopped —
And wandered in my Face —

My Feet kept drowsing — drowsing — still
My fingers were awake —
Yet why so little sound — Myself
Unto my Seeming — make?

How well I knew the Light before —
I could see it now —
'Tis Dying — I am doing — but
I'm not afraid to know —

467

We do not play on Graves —
Because there isn't Room —
Besides — it isn't even — it slants
And People come —

And put a Flower on it —
And hang their faces so —
We're fearing that their Hearts will drop —
And crush our pretty play —

And so we move as far
As Enemies — away —
Just looking round to see how far
It is — Occasionally —

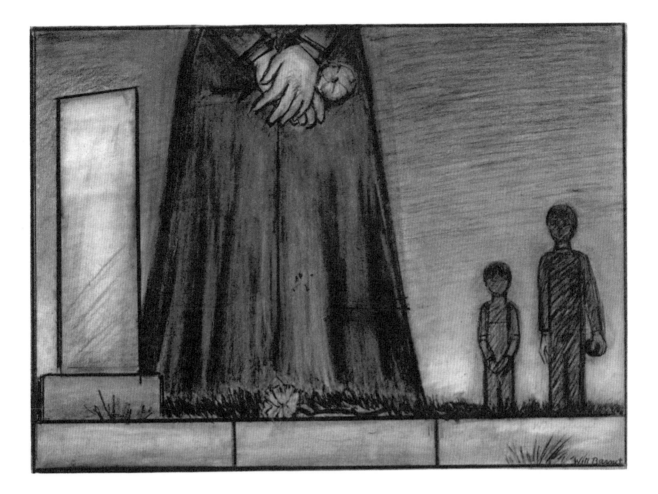

829

Ample make this Bed —
Make this Bed with Awe —
In it wait till Judgment break
Excellent and Fair.

Be its Mattress straight —
Be its Pillow round —
Let no Sunrise' yellow noise
Interrupt this Ground —

The Whole of it came not at once —
'Twas Murder by degrees —
A Thurst — and then for Life a chance —
The Bliss to cauterize —

The Cat reprieves the Mouse
She eases from her teeth
Just long enough for Hope to tease —
Then mashes it to death —

'Tis Life's award — to die —
Contenteder if once —
Than dying half — then rallying
For consciouser Eclipse —

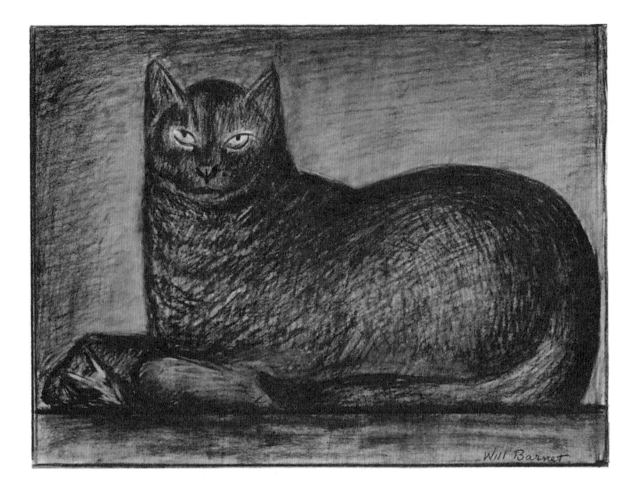

1202

The Frost was never seen —
If met, too rapid passed,
Or in too unsubstantial Team —
The Flowers notice first

A Stranger hovering round
A Symptom of alarm
In Villages remotely set
But search effaces him

Till some retrieveless Night
Our Vigilance at waste
The Garden gets the only shot
That never could be traced.

Unproved is much we know —
Unknown the worst we fear —
Of Strangers is the Earth the Inn
Of Secrets is the Air —

To analyze perhaps
A Philip would prefer
But Labor vaster than myself
I find it to infer.

Again — his voice is at the door —
I feel the old *Degree* —
I hear him ask the servant
For such an one — as me —

I take a *flower* —as I go —
My face to *justify* —
He never *saw* me — *in this life* —
I might *surprise* his eye!

I cross the Hall with *mingled* steps —
I — silent — pass the door —
I look on all this world *contains* —
Just his face — nothing more!

We talk in *careless* — and in *toss* —
A kind of *plummet* strain —
Each — sounding — shyly —
Just — how — deep —
The *other's* one — had been —

We *walk* — I leave my Dog — at home —
A *tender* — *thoughtful* Moon
Goes with us — just a little way —
And — then — we are *alone* —

Alone — if *Angels* are "alone" —
First time they *try* the *sky*!
Alone — if those "veiled faces" — be —
We cannot *count* — on High!

I'd give — to live that hour — *again* —
The *purple* — *in my Vein* —
But *He* must *count the drops* — himself —
My price for *every stain*!

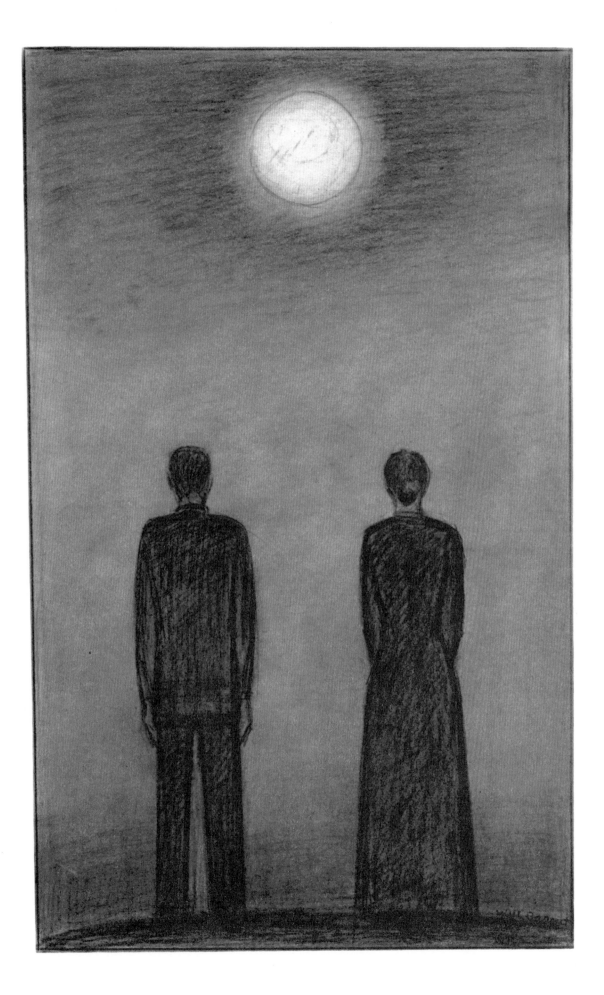

341

After great pain, a formal feeling comes —
The Nerves sit ceremonious, like Tombs —
The stiff Heart questions was it He, that bore,
And Yesterday, or Centuries before?

The Feet, mechanical, go round —
Of Ground, or Air, or Ought —
A Wooden way
Regardless grown,
A Quartz contentment, like a stone —

This is the Hour of Lead —
Remembered, if outlived,
As Freezing persons, recollect the Snow —
First — Chill — then Stupor — then the letting go —

1400

What mystery pervades a well!
That water lives so far —
A neighbor from another world
Residing in a jar

Whose limit none have ever seen,
But just his lid of glass —
Like looking every time you please
In an abyss's face!

The grass does not appear afraid,
I often wonder he
Can stand so close and look so bold
At what is awe to me.

Related somehow they may be,
The sedge stands next the sea —
Where he is floorless
And does not timidity betray

But nature is a stranger yet;
The ones that cite her most
Have never passed her haunted house,
Nor simplified her ghost.

To pity those that know her not
Is helped by the regret
That those who know her, know her less
The nearer her they get.

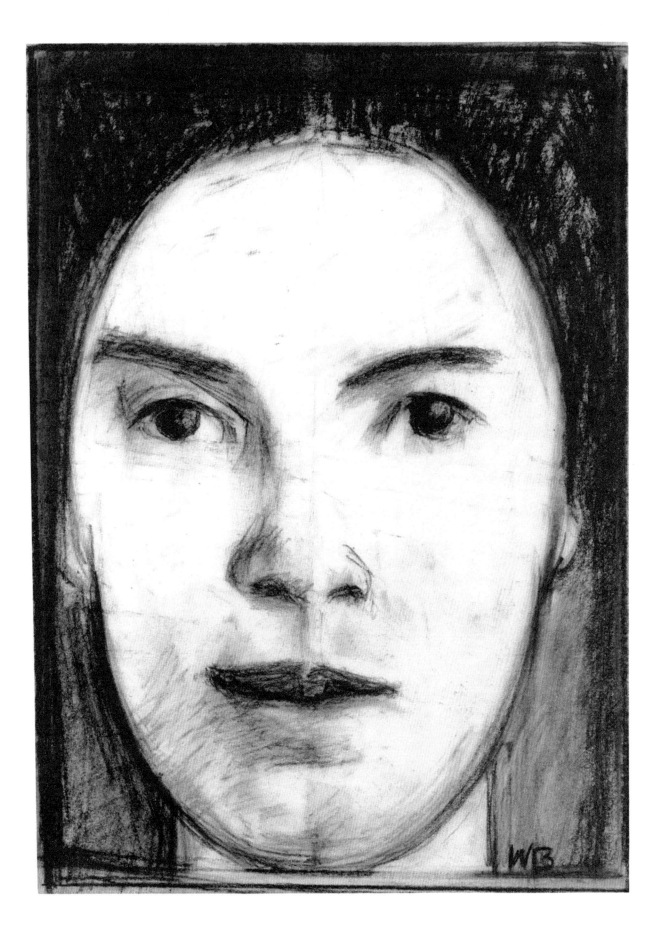

675

Essential Oils — are wrung —
The Attar from the Rose
Be not expressed by Suns — alone —
It is the gift of Screws —

The General Rose — decay —
But this — in Lady's Drawer
Make Summer — When the Lady lie
In Ceaseless Rosemary —

824

(second version)

The Wind begun to rock the Grass
With threatening Tunes and low —
He threw a Menace at the Earth —
A Menace at the Sky.

The Leaves unhooked themselves from Trees —
And started all abroad
The Dust did scoop itself like Hands
And threw away the Road.

The Wagons quickened on the Streets
The Thunder hurried slow —
The Lightning showed a Yellow Beak
And then a livid Claw.

The Birds put up the Bars to Nests —
The Cattle fled to Barns —
There came one drop of Giant Rain
And then as if the Hands

That held the Dams had parted hold
The Waters Wrecked the Sky,
But overlooked my Father's House —
Just quartering a Tree —

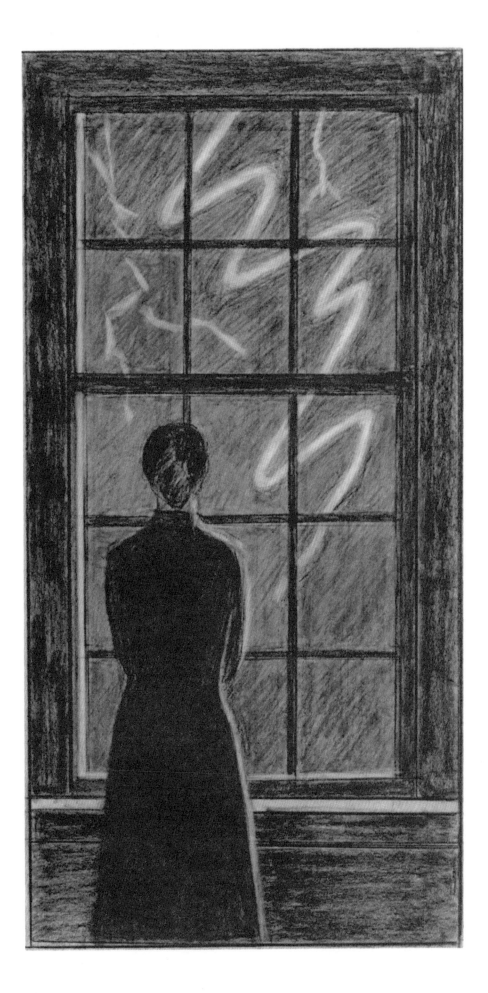

465

I heard a Fly buzz — when I died —
The Stillness in the Room
Was like the Stillness in the Air —
Between the Heaves of Storm —

The Eyes around — had wrung them dry —
And Breaths were gathering firm
For that last Onset — when the King
Be witnessed — in the Room —

I willed my Keepsakes — Signed away
What portion of me be
Assignable — and then it was
There interposed a Fly —

With Blue — uncertain stumbling Buzz —
Between the light — and me —
And then the Windows failed — and then
I could not see to see —

The Loneliness One dare not sound —
And would as soon surmise
As in its Grave go plumbing
To ascertain the size —

The Loneliness whose worst alarm
Is lest itself should see —
And perish from before itself
For just a scrutiny —

The Horror not to be surveyed —
But skirted in the Dark —
With Consciousness suspended —
And Being under Lock —

I fear me this — is Loneliness —
The Maker of the soul
Its Caverns and its Corridors
Illuminate — or seal —

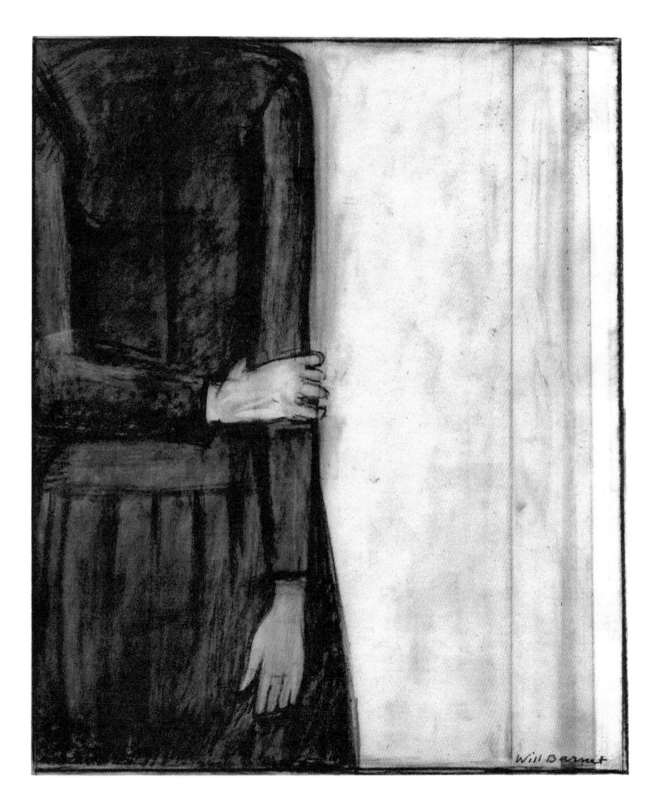

Delight — becomes pictorial —
When viewed through Pain —
More fair — because impossible
That any gain —

The Mountain — at a given distance —
In Amber — lies —
Approached — the Amber flits — a little —
And That's — the Skies —

A Light exists in Spring
Not present on the Year
At any other period —
When March is scarcely here

A Color stands abroad
On Solitary Fields
That Science cannot overtake
But Human Nature feels.

It waits upon the Lawn,
It shows the furthest Tree
Upon the furthest Slope you know
It almost speaks to you.

Then as Horizons step
Or Noons report away
Without the Formula of sound
It passes and we stay —

A quality of loss
Affecting our Content
As Trade had suddenly encroached
Upon a Sacrament.

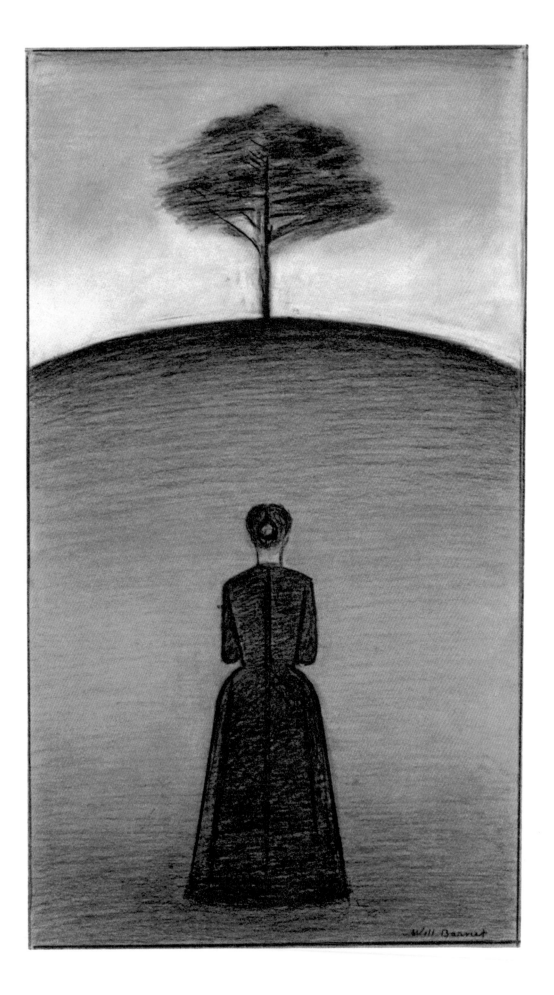

Some things that fly there be —
Birds — Hours — the Bumblebee —
Of these no Elegy.

Some things that stay there be —
Grief — Hills — Eternity —
Nor this behooveth me.

There are that resting, rise.
Can I expound the skies?
How still the Riddle lies!

1775

The earth has many keys.
Where melody is not
Is the unknown peninsula.
Beauty is nature's fact.

But witness for her land,
And witness for her sea,
The cricket is her utmost
Of elegy to me.

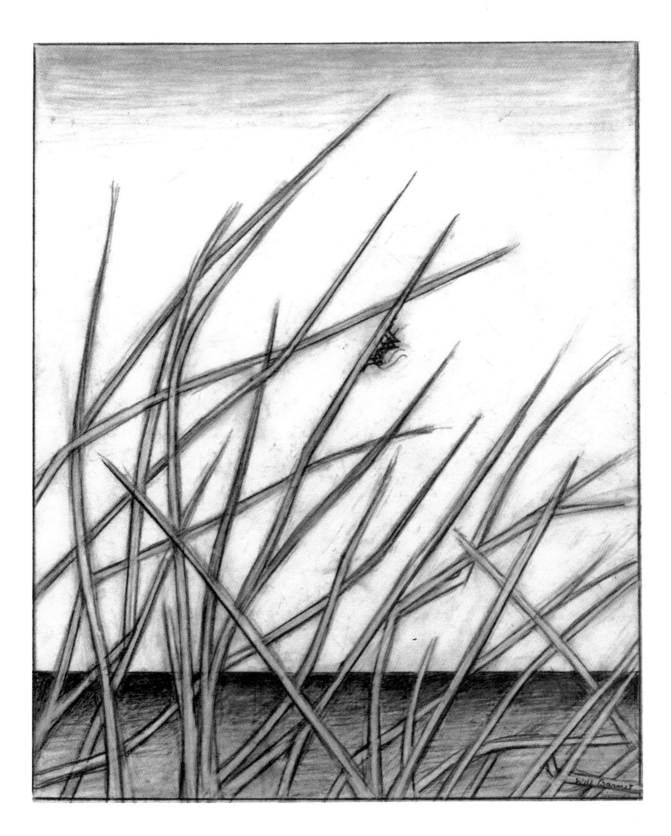

LIST OF DRAWINGS